Great African Americans
Entertainment

By Kaite Goldsworthy

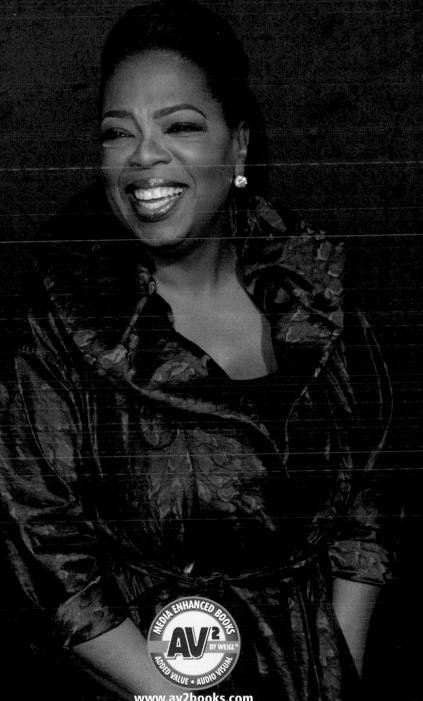

MEDIA ENHANCED BOOKS
AV²
BY WEIGL™
ADDED VALUE • AUDIO VISUAL

www.av2books.com

AV² provides enriched content that supplements and complements this book. Weigl's AV² books strive to create inspired learning and engage young minds in a total learning experience.

Your AV² Media Enhanced books come alive with...

Audio
Listen to sections of the book read aloud.

Key Words
Study vocabulary, and complete a matching word activity.

Video
Watch informative video clips.

Quizzes
Test your knowledge.

Go to **www.av2books.com**, and enter this book's unique code.

Embedded Weblinks
Gain additional information for research.

Slide Show
View images and captions, and prepare a presentation.

BOOK CODE

| T 8 5 1 9 6 3 |

AV² **by Weigl** brings you media enhanced books that support active learning.

Try This!
Complete activities and hands-on experiments.

... and much, much more!

Published by AV² by Weigl
350 5th Avenue, 59th Floor
New York, NY 10118

Website: www.av2books.com www.weigl.com
Copyright ©2012 AV2 by Weigl

Library of Congress Cataloging-in-Publication Data

Yasuda, Anita.
Entertainment / Anita Yasuda.
 pages cm. -- (Great African Americans)
ISBN 978-1-61690-659-7 (hardcover : alk. paper) -- ISBN 978-1-61690-663-4 (softcover : alk. paper)
1. African American art--Juvenile literature. I. Title.
N6538.N5Y37 2012
704.03'96073--dc22
 2010050181

Printed in the United States of America in North Mankato, Minnesota
1 2 3 4 5 6 7 8 9 0 15 14 13 12 11

062011
WEP290411

Weigl acknowledges Getty Images as its primary image supplier for this title.

Senior Editor: Heather Kissock
Art Director: Terry Paulhus

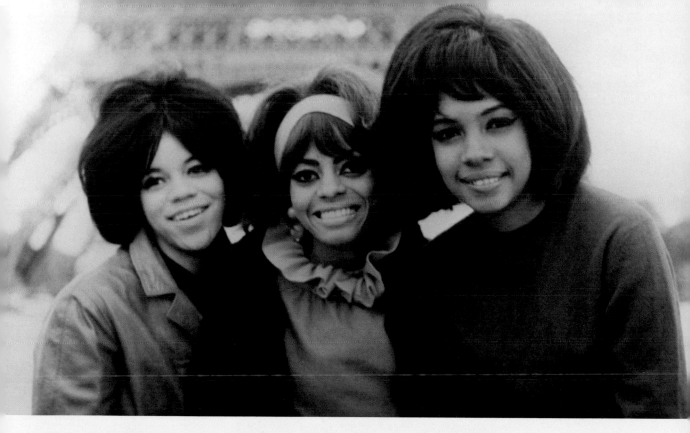

Contents

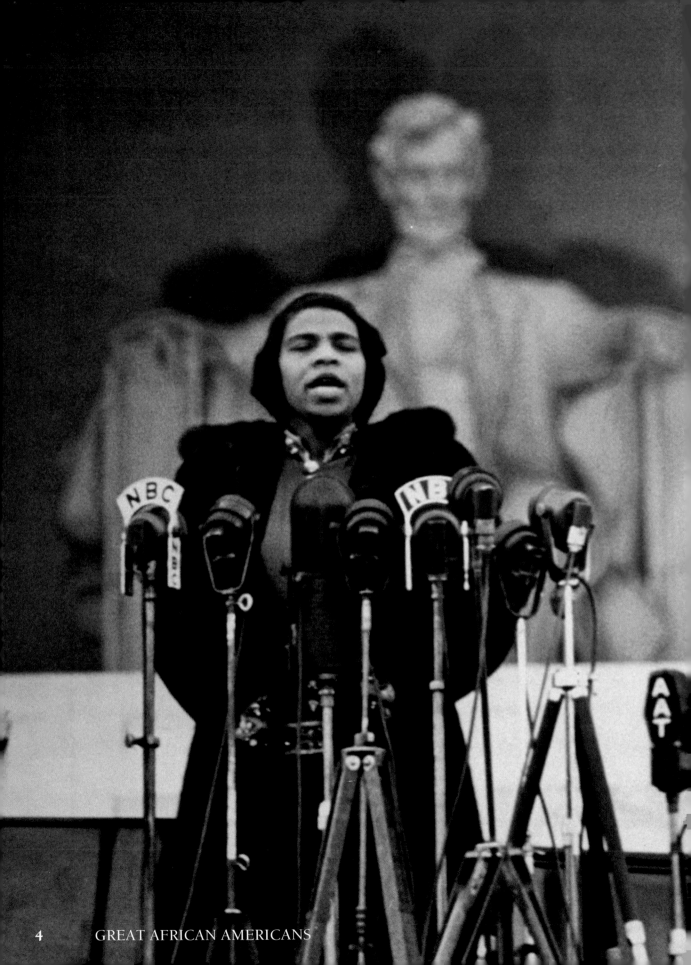

Play On

Music, song, and dance have long been part of the African American experience. This strong culture is rooted in African traditions. These traditions came to America with the first captured slaves from Africa almost 400 years ago.

Spiritual Music

Traditional African songs and dances were often spiritual. African Americans celebrated births, deaths, and marriages as well as the joys of everyday life with their music. For slaves in the United States, songs also became a way to pass time and lift spirits. African American slaves had lost every human freedom, but they still had music and song. Much of the music they sang in the plantation fields was about the hardships of slave life.

A Long Journey

Since those times, it has been a long journey for African Americans to reach acceptance and widespread popularity on the radios, television sets, stages, and movie screens of today. The history of African American entertainment has reflected the struggles for freedom, **civil rights**, and equality in the United States. During this long journey, many audiences have celebrated the achievements of great African American entertainers.

One historic celebration of African American performance took place on the steps of the Lincoln Memorial in Washington, D.C., in 1939. After being denied use of a "whites only" hall in the nation's capital, singer Marian Anderson performed a free open-air concert, arranged by First Lady Eleanor Roosevelt. The event drew an audience of 75,000 people.

Enormous Impact

The impact of African American artists and entertainers has been enormous. Some forms of music such as **blues**, **jazz**, and rock and roll would not exist without the pioneering talents of African American musicians. African American stage and film actors, dancers, and comedians also greatly influenced the entertainment industries in the United States and around the world.

The Early Years

Minstrel shows were popular from the 1840s to the early 1900s. The idea of them offends people today, however. These shows featured performers, often of European ancestry, wearing black makeup with exaggerated features, or blackface. The characters in these shows were often **racist** portrayals of African American speech, manners, and dress.

Later, starting in the 1860s, African Americans began performing in minstrel shows. For African Americans, it was the only way to make a living as an entertainer. Over time, as African American entertainers gained more influence, they worked to make the shows less offensive. Eventually, minstrel shows disappeared.

Other Shows

Vaudeville and **variety shows** were also common at this time. Because of **segregation**, a separate vaudeville tour was formed for African American entertainers. These vaudeville shows featured song and dance, juggling, magic, and comedy.

The Banjo

The plucked string instrument called a banjo originated in Africa. Slaves brought this instrument, made originally from gourds, to America. The banjo, with its round body and long neck, usually has five strings. Over time, it was adopted for use in various forms of music. The banjo has become an essential instrument in U.S. music, including folk music and a form of country music called bluegrass.

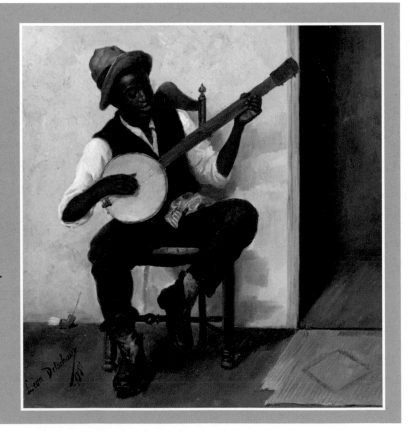

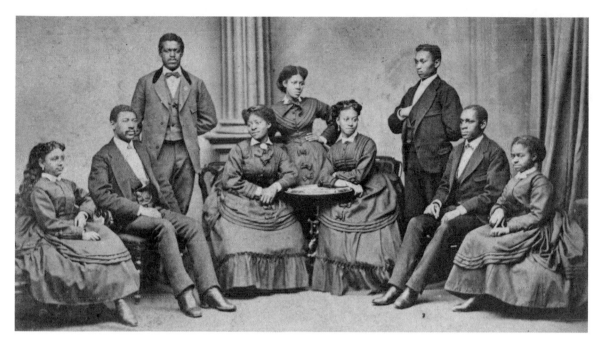

The Fisk Jubilee Singers included men and women.

Entertainers such as Bert Williams and partner George Walker were a popular vaudeville comedy act. Their 1901 recording of the song "Good Afternoon Mr. Jenkins" was one of the first recordings by African American artists. Williams went on to become a star in the Broadway productions called the Ziegfeld Follies. He was the highest-paid African American entertainer of his day.

Jubilee Singing Groups

In the 1870s, jubilee singing groups became extremely popular. These African American groups sang a cappella, or without musical accompaniment. They sang religious songs called **spirituals**. Many of these spirituals were originally slave songs. Religious songs that referred to a future happy time were called jubilees.

The Fisk Jubilee Singers were the most famous of these groups. Formed in 1871 at Fisk University in Nashville, Tennessee, the group toured the United States and Europe. The group's talent and perseverance began to challenge racial barriers. By 1873, the singers had performed for U.S. president Ulysses Grant as well as kings and queens in Europe.

New generations of Fisk Jubilee Singers still perform today. In 2008, the organization received a National Medal of Arts. It is the highest award given to artists by the U.S. government.

Scott Joplin and Ragtime

African American pianist and composer Scott Joplin is known as the King of **Ragtime**. Born in Missouri in 1867 or 1868, Joplin taught himself to play the piano at the home where his mother worked. A local German-born music teacher named Julius Weiss noticed Scott's early talents and began teaching him. Weiss exposed his young student to European classical music and opera. These music forms influenced Scott Joplin's lively ragtime music.

Unique Music

Before Scott Joplin, audiences did not consider ragtime, which was often played in bars, a respectable form of music. Joplin helped listeners recognize ragtime as a serious musical style. His ragtime blends classical sounds and **tempos** with African American music such as spiritual hymns and **work songs**. In his lifetime, Joplin composed a ballet, two operas, and more than 40 ragtime pieces.

Treemonisha, an opera composed by Scott Joplin in 1910, was performed on Broadway to celebrate its 100th anniversary.

"Maple Leaf Rag"

Scott Joplin published the ragtime piece called "Maple Leaf Rag" in 1899. He wrote it in honor of the Maple Leaf Club, an African American social club in Sedalia, Missouri. "One day," Joplin said, "the 'Maple Leaf' will make me king of ragtime composers." Sales were slow at first but then soared. No other song Joplin composed in his lifetime matched its success. In fact, "Maple Leaf Rag" is now considered the most influential ragtime song of all time.

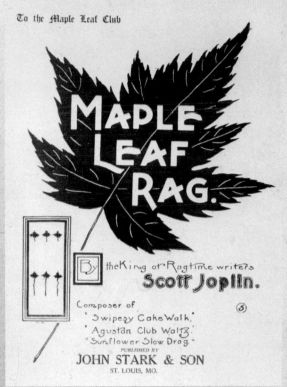

Joplin's "Maple Leaf Rag" sold more than one million copies of sheet music. It was the first instrumental song to sell that many copies.

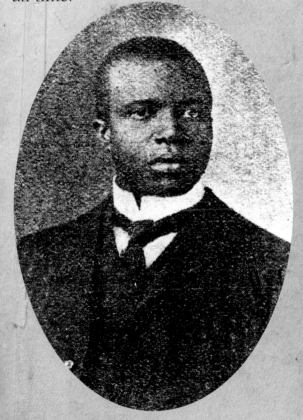

In the decades following Joplin's death in 1917, appreciation for his contributions to music has grown.

New Interest

Audiences showed new interest in Joplin's music in the 1970s. Musician and music historian Joshua Rifkin recorded *Scott Joplin: Piano Rags* in 1971. The album sold more than one million copies. The score for the 1973 Academy Award–winning film *The Sting* also featured Joplin's music. The film popularized the 1902 song "The Entertainer." In 1976, Scott Joplin won a Pulitzer Prize, almost 60 years after his death.

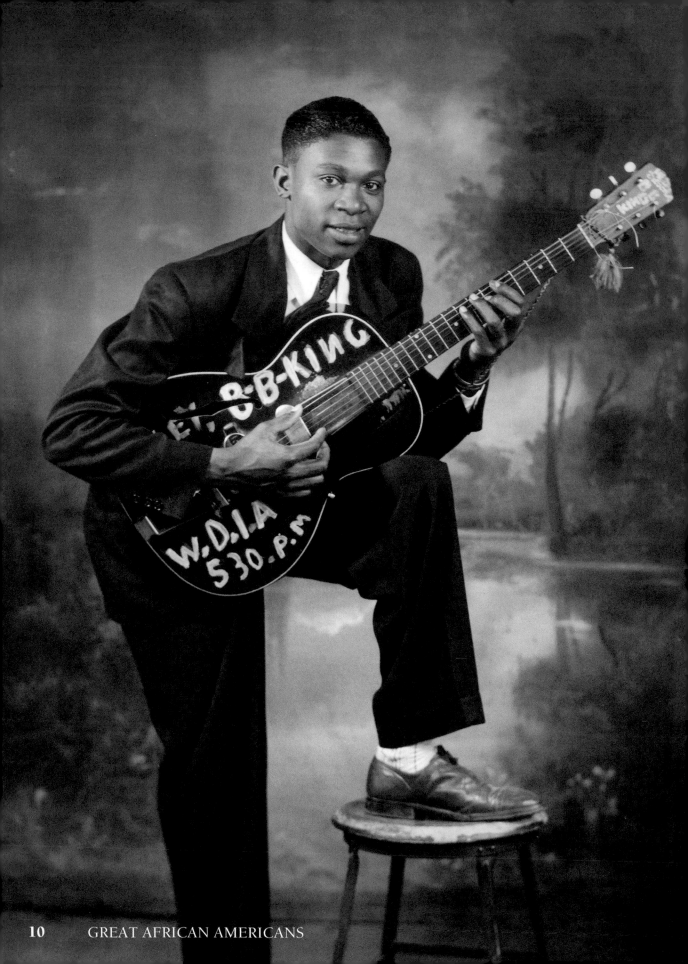

Singing the Blues in the 1920s

African Americans were still struggling to gain equal rights in the twentieth century. That struggle influenced the development of a new form of music called the blues. Blues evolved into a distinct form of music during the 1920s.

Blues music developed from African American spirituals, work songs, and **field hollers** of the nineteenth century. The blues have a sad tone to the music. The **lyrics** often tell of hard times, cruelty, and unjust treatment.

To the Cities

In the 1910s and 1920s, the **Great Migration** took place. Many African Americans moved from the countryside of the South to the cities and towns of the northern states. They were looking for better job opportunities and more equal treatment.

These African Americans brought blues music with them to big cities such as Chicago, Illinois. Blues artists who began careers in the 1930s and 1940s included Robert Johnson, Muddy Waters, and King of the Blues B. B. King. The music of these artists continues to influence popular songs today.

Harlem Renaissance

The Harlem Renaissance was a movement centered in New York City's Harlem neighborhood during the 1920s and 1930s. *Renaissance* means "rebirth." The Harlem Renaissance was a celebration of heritage and cultural pride through the arts. African American writers and artists of all types came together to support each other and challenge **stereotypes**.

During this time, many types of African American music began to gain popularity with audiences of mostly European ancestry. Jazz, blues, and **gospel music** all thrived during the Harlem Renaissance.

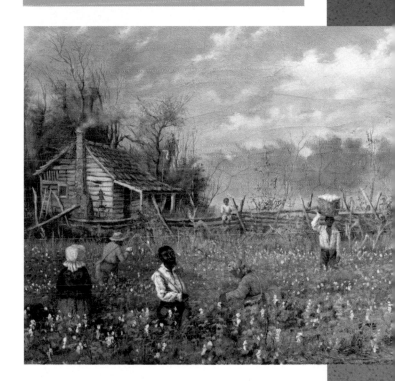

Slaves working in plantation fields sang traditional call-and-answer songs called field hollers.

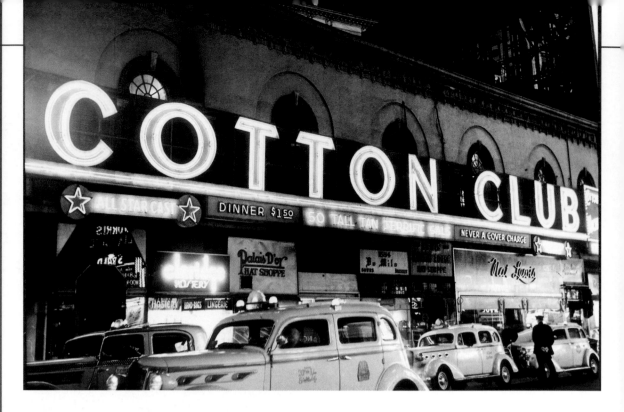

The Creation of Jazz

Jazz is a uniquely American art form. It blends European and American musical styles with the music of African American slaves. Jazz evolved from blues and ragtime. It was mostly African American entertainers who created this kind of music. Jazz was developed in the late 1800s and peaked in popularity in the 1920s and 1930s during the Harlem Renaissance.

Cotton Club Jazz

The Cotton Club in Harlem was one of New York City's most famous nightclubs. Many African American jazz singers, musicians, and dancers began their careers here. Duke Ellington, Billie Holliday, Cab Calloway, Lena Horne, Coleman Hawkins, Sammy Davis Jr., and many others performed at the Cotton Club.

The Cotton Club featured many African American performers. However, it denied admission to African American customers. The club's audiences may have enjoyed African American entertainers, but they did not usually support equal rights for African Americans.

Segregation Laws

Segregation of the races was common at this time. Laws that supported segregation in the South were called **Jim Crow laws.** These laws created separate, and usually inferior, areas

and services for African Americans. African Americans were forced to use separate bathrooms, store dressing rooms, hotels, and restaurants. African Americans entertainers, often underpaid and unfairly treated, could play in only certain theaters and had to use separate entrances. This kind of segregation was common until the **Civil Rights Act of 1964** overturned Jim Crow laws.

Apollo Theater

The Apollo Theater in Harlem played an important role in the history of African American entertainment. In the 1930s, this music hall welcomed African American audiences and supported African American entertainers. It was the only theater to hire African Americans for backstage jobs. The Apollo's famous Amateur Night launched artists such as singers Pearl Bailey and Ella Fitzgerald. James Brown, Stevie Wonder, and the Jackson 5 as well as later performers such as **rapper** Lauryn Hill have performed at the Apollo Theater. Shows still run at the historic theater today.

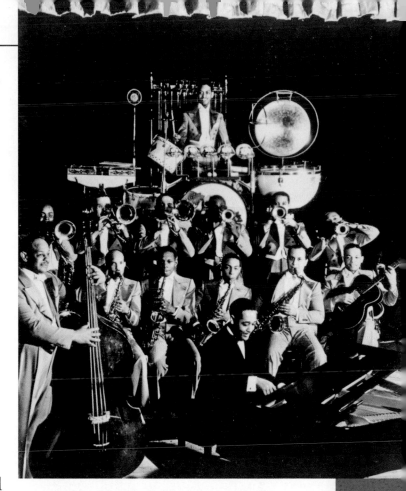

Pianist, bandleader, and composer Duke Ellington performed regularly at the Cotton Club in the 1930s.

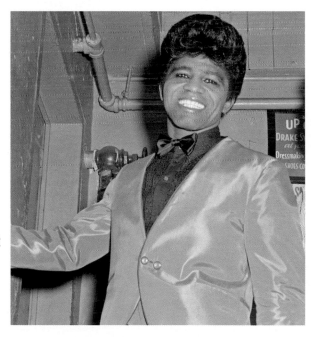

James Brown recorded one of the first "live and in concert" albums, called *Live at the Apollo,* in 1963.

The Jazzman Named Satchmo

Louis Armstrong was known for his distinctive gravelly voice, big smile, and even bigger personality. People called him "Satchmo," short for Satchelmouth, because of the way his mouth and cheeks puffed out when he played the trumpet. Satchmo is one of the most important and influential musicians in the history of jazz.

Childhood

Born in 1901 in a poor section of New Orleans, Louisiana, Louis Armstrong taught himself to play a type of trumpet called a cornet at an early age. While at a home for troubled boys, he joined a band. He earned a living playing on steamboats. Then, he moved to Chicago to play with King Oliver's Creole Band.

By the time he left for New York City, Armstrong had switched to the trumpet. His enthusiastic style of playing and creative solos made him popular on the jazz circuit. Armstrong's exceptional talent and easygoing nature helped him find success and acceptance in a world full of racial divides.

Louis Armstrong was an internationally known jazz trumpeter, singer, and bandleader.

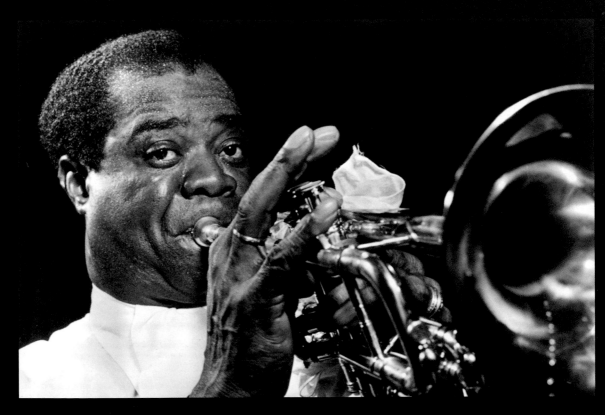

Changes to Jazz

Before Armstrong, jazz mostly featured a group of musicians performing, with no emphasis on any single instrument or artist. Satchmo changed jazz forever with his new style of **soloing**. His solos were based on **improvisation**. Armstrong chose freedom of expression in the music over playing the notes exactly as they were written on sheet music. He allowed the music to tell a story, taking his audience along with him.

Armstrong was the inventor of **scat singing**. This type of vocalizing features syllables, nonsense words, and sounds made in a rhythmic way. Armstrong used his voice like an instrument.

Scat was first recorded on Louis Armstrong's 1926 song "Heebie Jeebies." One story says that while recording the song, Armstrong dropped his sheet of music. The producers in the studio urged him to keep singing, so he did, with a string of nonsense words and sounds.

Louis Armstrong died in New York City on July 6, 1971. He was 70 years old. The following year, Armstrong was awarded a Grammy Award for lifetime achievement in music.

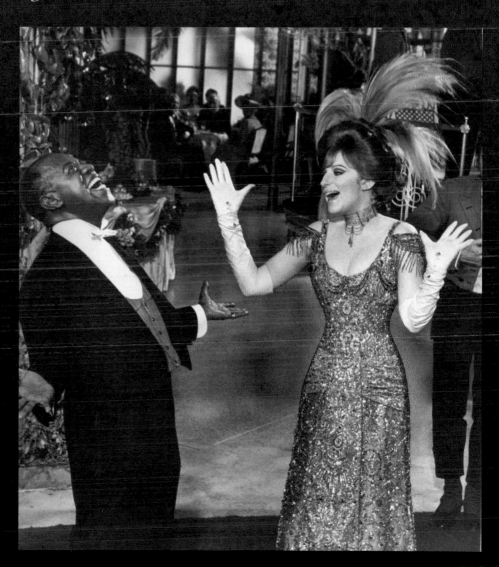

Louis Armstrong was a gifted comic actor. He appeared in more than 30 films, including the popular 1969 *Hello, Dolly!* with singer Barbra Streisand.

First Lady of Song

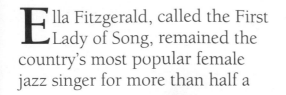

Ella Fitzgerald, called the First Lady of Song, remained the country's most popular female jazz singer for more than half a century. She had an amazing vocal range. Audiences loved her ability to sing many different styles of music, from jazz to nursery rhymes. When she was 21, Fitzgerald made a jazz recording of the nursery rhyme "A-Tisket, A-Tasket" that made her famous. The song hit number one on the charts and sold more than one million copies.

Like Louis Armstrong, Ella Fitzgerald was known for her scat singing. She could imitate instruments with her voice. She played at top venues around the world with jazz greats such as Duke Ellington, Nat King Cole, Frank Sinatra, Dizzy Gillespie, and Count Basie.

In 1959, Ella Fitzgerald became the first African American woman to win a Grammy Award. During her career, Fitzgerald won 13 Grammy Awards. She sold more than 40 million albums.

The First Lady of Song performed 26 times at the prestigious Carnegie Hall in New York City.

Ella Fitzgerald sang "A-Tisket, A-Tasket" throughout her career.

Discrimination

Like other African American entertainers of the time, Fitzgerald faced **discrimination** on the job. Her manager insisted she receive the same treatment as any other performer. However, she was not permitted to stay in some hotels or perform in certain concert halls. In 1954, she and her band were denied seats on an airplane, apparently because of their race.

A Life of Music

Ella Fitzgerald died in 1996 at the age of 79. In her lifetime, she recorded more than 200 albums. Her recordings of songs by composers George Gershwin, Cole Porter, and Irving Berlin, and others remain popular today.

Lady Day

Jazz singer Billie Holiday was born in 1915, just two years before Ella Fitzgerald. Nicknamed Lady Day, Holiday was discovered while performing in a Harlem club in 1933. She was known for her beautifully expressive voice. Her most popular songs included "Strange Fruit," "God Bless the Child," and "My Man." Holiday was one of the first female African American singers to work with an orchestra of European ancestry. She died at the age of 44.

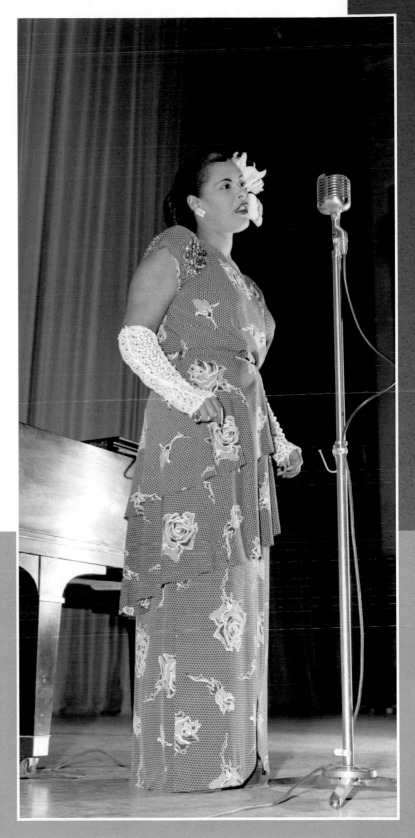

The 1940s

By the 1940s, many African American entertainers were achieving popularity with audiences of all races. Their contributions to music and the arts were gaining wider recognition. The increasing popularity of African Americans in entertainment may have helped to lead the way to greater acceptance of all African Americans in other areas of American life.

R&B

In the 1940s, an important new style of music emerged. It was called **rhythm and blues,** or R&B. R&B evolved from the blues and jazz. The term *R&B* was often used to describe all types of African American music. In fact, R&B later expanded to include other types of music such as gospel and **soul**.

Musician and bandleader Louis Jordan is known as the Father of Rhythm and Blues. His style of music was a blend of jazz and blues often called jumpin' jive. This music later inspired rock and roll.

Negro Freedom Rallies

Between 1945 and the passage of the Civil Rights Act of 1964, Negro Freedom Rallies took place at Madison Square Garden in New York City every year. These rallies featured African American civil rights leaders, writers, poets, and entertainers. They informed and inspired others in the fight against injustice. Duke Ellington appeared at many rallies, as did dancer Pearl Primus.

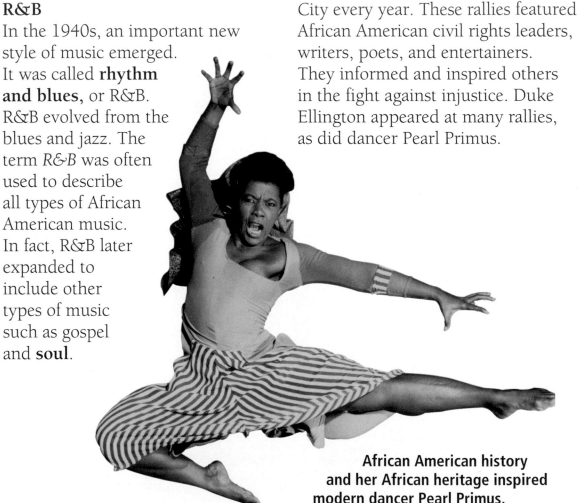

African American history and her African heritage inspired modern dancer Pearl Primus.

Quick Facts

In 1940, Hattie McDaniel became the first African American to win an Academy Award. She won the Oscar for best supporting actress for her role as Mammy in the 1939 film *Gone with the Wind*.

Race films were popular in the 1940s. African Americans wrote, produced, directed, and acted in these low-budget films. They were shown only in segregated theaters.

Trumpeter and bandleader Miles Davis recorded his *Birth of the Cool* in 1949 and 1950. It launched a type of modern jazz called cool jazz in the 1950s.

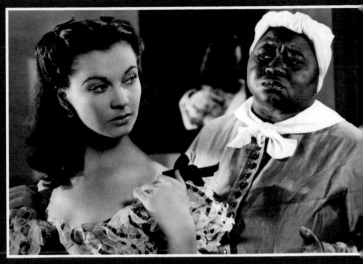

Gone with the Wind

The Rise of Gospel Music

Gospel music is a type of religious music that combines jazz, spirituals, and folk music. It is often sung in churches. With her rich, soulful voice, Mahalia Jackson helped popularize this kind of music. She made classic recordings of "Go Tell It on the Mountain" and "Amazing Grace." Jackson was the first African American gospel singer to perform at Carnegie Hall in New York City. In 1968, she sang at the funeral of civil rights leader Martin Luther King Jr.

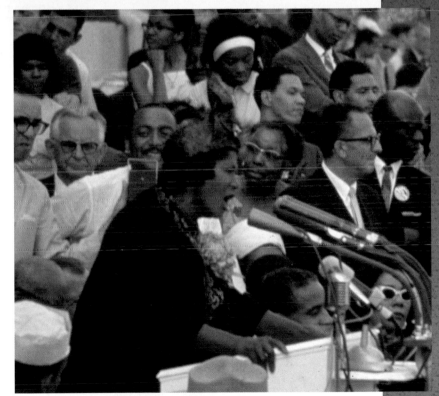

Mahalia Jackson sang for 250,000 people at the 1963 civil rights rally called the March on Washington.

Chuck Berry and the Birth of Rock and Roll

Music today would be very different without the influence of singer, songwriter, and guitarist Chuck Berry. His music has entertained generations of audiences. His performances have inspired many other musicians.

Born in St. Louis, Missouri, in 1926, Charles Edward Anderson Berry enjoyed playing blues guitar. He learned from fellow musician T-Bone Walker.

In 1955, Berry visited Chicago hoping to get a record contract.

First Song

The most famous song that Berry played in his first recording session was called "Maybellene." Recorded in 1955, "Maybellene" combined R&B with country music. Though country music was popular at the time, it was unfamiliar to many African American communities. Berry helped musical styles cross over between groups. "Maybellene" was an instant hit. Many people believe Berry started rock and roll with this song.

Chuck Berry is known as the Father of Rock and Roll.

Berry's other rock and roll hits included "Roll over Beethoven," "Rock and Roll Music," and "Johnny B. Goode." Part of Berry's success was his appeal to all audiences. His lyrics explored topics that teenagers especially understood, such as high school, fast cars, and dating.

Audiences

Berry was also known for his guitar solos and showmanship. He often interacted with his audiences. Berry sometimes changed the lyrics to see if his fans were listening.

When Berry played at the Cosmopolitan Club in St. Louis, he decided to include some country songs. His mostly African American audience found it fun to try dancing to the music. In time, Berry had a mixed audience of African Americans and others dancing to his catchy music.

Chuck Berry was **inducted** into the Rock and Roll Hall of Fame in 1986. He was among the first group of performers ever to be inducted. Berry still performs today.

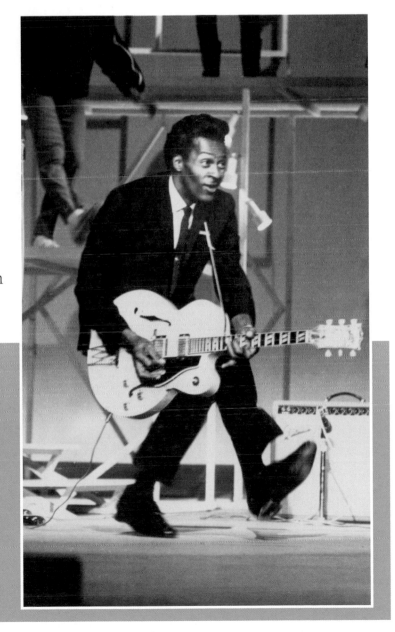

Duck Walk

Chuck Berry's classic one-legged hop while playing the guitar was nicknamed the duck walk. Many musicians have imitated the move since then. Berry's duck walk, guitar riffs, and stage presence may have inspired Elvis Presley, the Beatles, and the Rolling Stones.

The 1950s

During the 1950s, the **civil rights movement** was still in its early years. Americans had begun to call for equality and organize protests against segregation in the South. The music and entertainment industries of the day mirrored their times.

New Music

The popular R&B music of the 1940s had given birth to a new type of music in the 1950s. It was called rock and roll. African American artists, including Chuck Berry, Little Richard, Fats Domino, and Bo Diddley, played an important part in creating this new music. Electric guitars and upbeat tempos helped create the rock and roll sound.

At this time, many radio stations played songs only by artists of European ancestry. These artists often recorded songs that had already been recorded by African Americans. Bill Haley and His Comets, for example, popularized "Rocket 88" and "Shake, Rattle and Roll" after African Americans Ike Turner and Big Joe Turner had recorded them. As a result, many African American entertainers were not recognized for their contributions until much later in their careers.

Alvin Ailey and his dance theater toured the world.

Dance World

Alvin Ailey, born in Texas in 1931, founded his American Dance Theater in 1958 with an **ensemble** of African American dancers. His choreography to music such as the blues brought international success. Alvin Ailey American Dance Theater gave African American dancers a chance to perform despite segregation. Ailey created more than 79 ballets during his career.

A Television First

Portrayals of African Americans on television over the years have reflected the social and political viewpoints of the time. Television shows in the 1950s such as *Amos 'n' Andy* and *The Beulah Show* featured African Americans as domestic help or dishonest and lazy people. The National Association for the Advancement of Colored People, or NAACP, called for an end to these shows, but the studios refused.

In 1956, singer and songwriter Nat King Cole became the first African American to host his own television show. *The Nat King Cole Show* was a popular variety show. Television stations in many southern states refused to air it, however.

Film Stars

The first true African American film stars began to appear during the 1950s. Sidney Poitier, Harry Belafonte, Ruby Dee, and Dorothy Dandridge all started to break ground in the film industry. Dandridge starred in eight films in the 1950s, including *Carmen Jones* for which she was nominated for an Academy Award.

Dorothy Dandridge and Harry Belafonte starred in the 1954 musical film *Carmen Jones* based on the famous opera *Carmen*.

Quick Facts

Marian Anderson became the first African American woman to perform with the Metropolitan Opera Company in New York City in 1955.

In 1956, Arthur Mitchell joined the New York City Ballet. He was the ensemble's first African American dancer.

In 1959, Lorraine Hansberry's *A Raisin in the Sun* became the first drama written by an African American woman to open on Broadway.

Berry Gordy and the Rise of Motown

Motown Records began in Detroit, Michigan, in a small house nicknamed Hitsville USA. Berry Gordy founded the company in 1959. He was the first African American to own a record label.

Motown Record Corporation developed into one of the world's most influential and diverse independent music companies. Motown's impact on music and popular culture was immense. Gordy's Motown label launched the careers of many African American musicians and artists.

The Motown Sound
Motown produced and distributed all types of music. The record company is perhaps most famous for popularizing a blend of R&B, soul, and pop that became known as the Motown Sound. The Motown Sound allowed Gordy's mostly African American roster of artists to cross over into mainstream popular music.

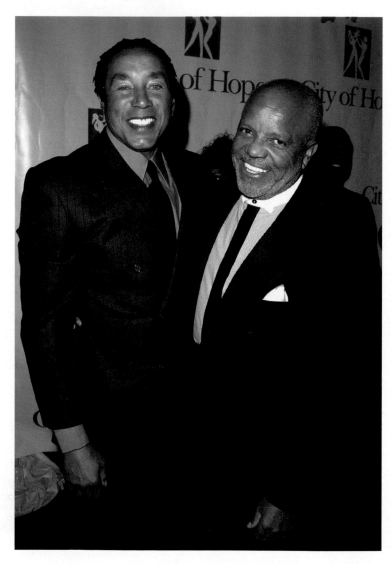

R&B singer Smokey Robinson helped contribute to the success of Berry Gordy's Motown Records.

Diana Ross and the Supremes was one of Motown's most successful acts in the 1960s.

Hit List

The Motown label's list of hit songs and legendary artists is long. In the 1960s and early 1970s, artists such as the Temptations, the Four Tops, Gladys Knight and the Pips, Diana Ross and the Supremes, the Jackson 5, Stevie Wonder, Smokey Robinson, Marvin Gaye, and many others racked up 110 top-10 songs on the Motown label. That success continued into the 1980s and early 1990s with performers such as Lionel Richie, Boyz II Men, and Erykah Badu.

Motown Records celebrated its 50th anniversary in 2009. Now owned by Universal Music Group, the label continues to produce hit albums today. Recent Motown artists include rapper Nelly and R&B singer Akon.

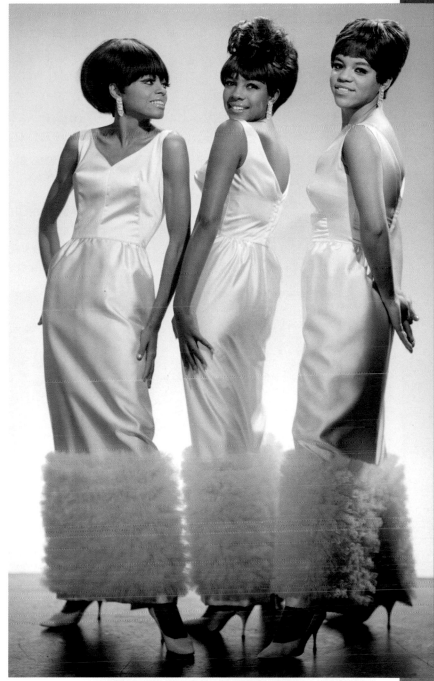

TECHNOLOGY LINK
To learn more about the history of soul music and Motown legends, visit **http://classic. motown.com/timeline**.

The 1960s

The 1960s were important years in the history of the United States. Americans held demonstrations and marches to oppose segregation. Civil rights activists continued to demand equality for all. At last, the U.S. Congress passed the Civil Rights Act of 1964. The act outlawed discrimination in most public facilities. African Americans began to experience equality for the first time.

Soul Music

It was during this time that soul music, with its elements of gospel and R&B, became popular. Soul singers such as Aretha Franklin and Sam Cooke had some of the

Singer and pianist Ray Charles helped create soul music. His 1955 song "I've Got a Woman" is considered one of the first soul songs.

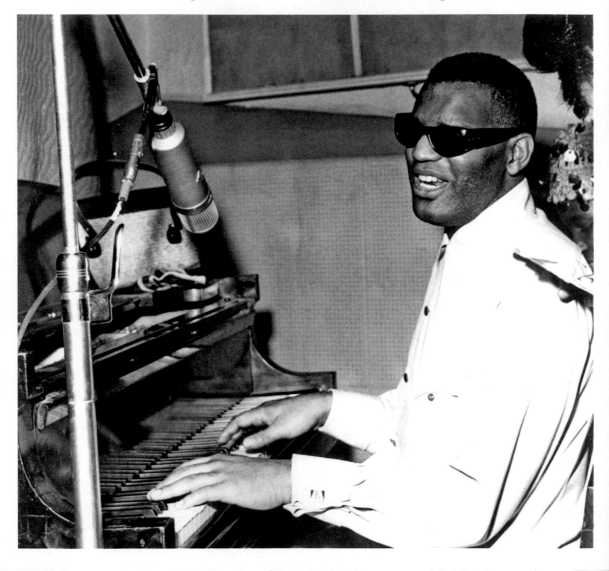

big hits of the 1960s. Franklin's 1967 "Respect" became an enormous success.

This music's popularity also made it a platform for the civil rights movement. Songs communicated African American pride and demanded justice. Motown's soul groups such as the Temptations and the Supremes dominated the music scene. Radio stations everywhere played their music.

Bill Cosby won three Emmy Awards for his work in the television series *I Spy*, which costarred Robert Culp.

Television Roles

In television and film, the 1960s were a time of change in the African American community. Actor and comedian Bill Cosby became the first African American to costar in a dramatic television series, *I Spy*, in 1965. Stereotypes were finally becoming less acceptable, making way for more honest and accurate portrayals of African American people.

Diahann Carroll played a nurse and widowed single mother in the **sitcom** *Julia*. Hers was an African American character portrayed positively. She became the first female African American to win a Golden Globe Award.

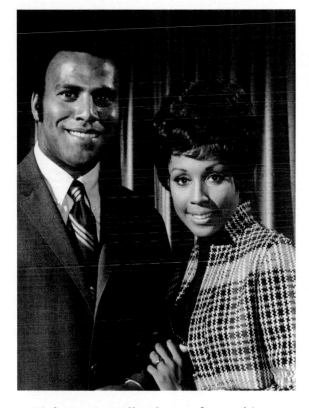

Diahann Carroll, who performed in *Julia* with Fred Williamson, was the first African American woman to star in her own television series.

Sidney Poitier Wins an Academy Award

A ctor Sidney Poitier is an American film legend. His intelligent portrayals of proud, strong characters defined his career and inspired a generation of actors and fans. Audiences admired him for his style and class as well as for his handsome looks. Poitier's work paved the way for many other talented African American actors.

Firsts in Film

Poitier was born in 1927 in Miami, Florida. He spent his childhood in the Bahamas, giving him his well-known soft accent. At 16, Poitier moved to New York City. He worked as a janitor at the American Negro Theater in exchange for acting lessons.

After many years on the stage, Poitier made his Hollywood debut in the 1950 film *No Way Out*. Many of his films directly addressed the racism and injustice that African American people faced.

Sidney Poitier's career featured a number of firsts for African Americans. He was the first African American to be nominated for an Academy Award for a leading role. The movie was *The Defiant Ones*, released in 1958. Then, he became the first African American to win an Academy Award for a leading role. He was honored for his work in the 1963 film *Lilies of the Field*.

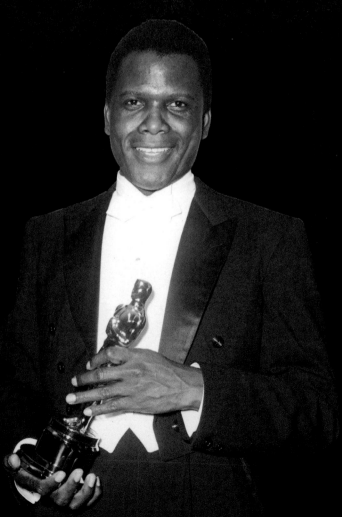

Sidney Poitier won his first Academy Award in 1964.

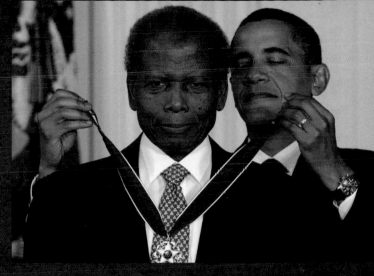

President Barack Obama gave the Presidential Medal of Freedom to Poitier during a White House ceremony in 2009.

One of Poitier's best-known roles was Detective Virgil Tibbs in the 1967 movie *In the Heat of the Night*. The film tells the story of an African American detective investigating a murder in a southern town. The film won five Academy Awards.

Poitier was not afraid to tackle controversial subjects. His film *Guess Who's Coming to Dinner* dealt with the rarely discussed subject of interracial marriage. When the film debuted in 1967, marriage between people of different races had only recently been legalized in all U.S. states. The film, also starring Katharine Hepburn and Spencer Tracy, was nominated for eight Academy Awards.

Later in his career, Poitier turned to directing. He has also been a political symbol. Poitier serves as the Bahamas representative, or ambassador, to Japan.

In *Lilies of the Field*, Poitier played a construction worker who helps build a chapel in the Arizona desert.

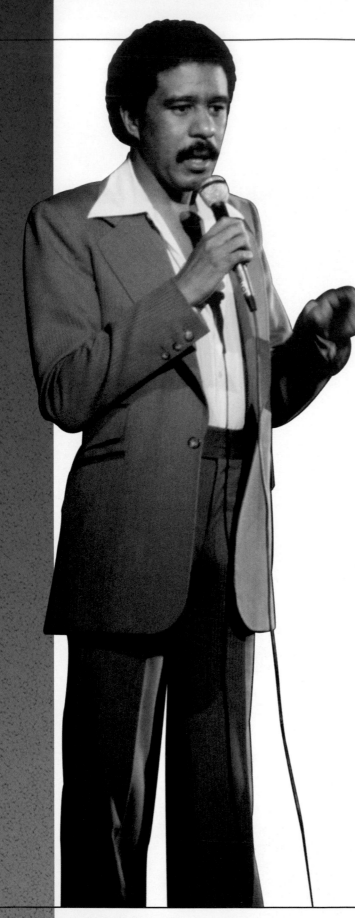

The 1970s

By the 1970s, the advances of the 1960s and the civil rights movement brought more opportunities for African Americans in the entertainment industry. African American musicians continued to thrive. African American comedians became popular. Television shows were starting to portray typical African American families. Alex Haley's *Roots: The Saga of an American Family* aired on national television in 1977. About 130 million viewers watched the dramatic miniseries about slavery.

Good Times was the first television series to show a working class African American family. The sitcom dealt with real-life challenges such as parenting teenagers, financial woes, and other social issues. Other popular shows were *The Jeffersons* and *Sanford and Son*, which starred comedian Redd Foxx. The 1970s also saw the first entirely African American television cartoon, *Fat Albert and the Cosby Kids*, created and hosted by Bill Cosby.

While Bill Cosby poked fun at familiar topics in his stand-up routines, Richard Pryor found humor in the gritty issues of racism and inner-city life.

Humor

Comedians in the 1970s such as Bill Cosby, Richard Pryor, and Flip Wilson entertained a wide, mixed audience. Using humor, they shared their experiences as African Americans. In addition to entertaining audiences, they helped minimize differences between people of different races. Wilson had his own television variety show. Cosby and Pryor regularly packed theaters with their stand-up routines.

On the Music Scene

In 1973, Stevie Wonder became the first African American artist to win a Grammy Award for best album. Wonder had been a child star, signing with Motown at the age of 11. At just 13, he became the youngest person to have a number-one hit single. Stevie Wonder's musical abilities and unique use of keyboards and synthesizers changed popular music.

Meanwhile, other artists such as James Brown were moving soul music toward a new style called funk. Funk was a type of soul or jazz music that made listeners want to dance because it had more rhythm. Funk music still influences many modern recording artists today.

Blaxploitation Films

In the 1970s, a new type of movie produced by and for African Americans appeared. The mostly action or crime-fighting films were produced quickly and cheaply. The featured characters were often stereotypes. Some people believed these movies exploited African Americans. They were dubbed **blaxploitation films**.

So-called blaxploitation films were among the first to feature African Americans in leading roles, however. The 1971 film *Shaft*, starring actor Richard Roundtree, is probably the best-known blaxploitation film. These movies influenced many of today's African American filmmakers, including John Singleton and Spike Lee.

Michael Jackson: King of Pop

One of the most influential and popular entertainers of all time was Michael Jackson. His vocal style and innovative dancing had a profound impact on both music and popular culture.

The Jackson 5

Born in Indiana in 1958, Michael Jackson was the eighth of 10 children. Michael's father was a former musician. He believed in the talent of his sons and formed a band called the Jackson 5. Even at five years old, Michael had the vocal ability to lead a group.

After signing with the legendary Motown record label in 1968, the group had its first number-one hit with the song "I Want You Back." Other hits followed, including "ABC," "I'll Be There," and "The Love You Save." In 1971, Michael released a solo album. The 13-year-old made the charts with his single "Got to Be There."

Solo Work

Michael Jackson had the chance to work with a talented producer named Quincy Jones on his next solo project. Their first album together was 1979's *Off the Wall*. It produced a string of hits, including "Rock with You," "She's Out of My Life," and the Grammy Award–winning "Don't Stop 'Til You Get Enough."

Jackson's solo career was already thriving when he released the album *Thriller* in 1982. The songs "Billie Jean" and "Beat It" went to number one on the charts. Five other songs made it into the top 10. The album also gave Jackson the chance to show off his dance and choreography skills in a number of live performances and music videos.

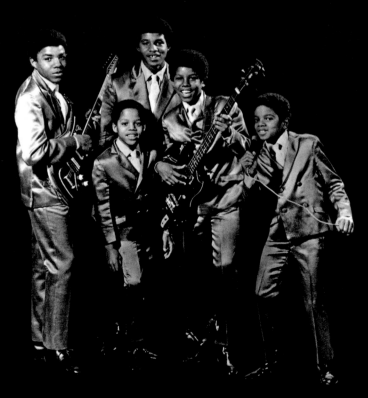

Michael Jackson was the youngest and most popular member of the Jackson 5.

A Video First

Jackson's music videos helped to shape this new art form. His video for the song "Thriller" was almost a short film. It included a plotline, special effects, makeup, and dance sequences. It even featured a voice-over by famed horror-film actor Vincent Price. The popular video helped the album to stay at number one for 37 weeks. Jackson also won eight Grammy Awards for his work on *Thriller*.

After *Thriller*

Jackson's follow-up albums *Bad* and *Dangerous* both topped the charts, and 1995's *HIStory*, and 2001's *Invincible* sold well. No subsequent albums could match the success of *Thriller*, however.

Michael Jackson, the self-proclaimed King of Pop, died suddenly on June 25, 2009, at the age of 50. He had been about to embark on a world tour. Album sales after his death made him the best-selling artist of 2009. The world mourned the loss of a pop legend.

Michael Jackson debuted a dance technique called the moonwalk for a television tribute to Motown in 1983. During a performance of the song "Billie Jean," he glided backwards while appearing to walk forward.

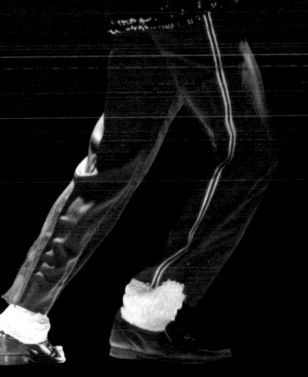

Quick Facts

Jackson released the song "Ben" in 1972 for the film of the same name. It became his first number-one hit as a solo artist. He was 14 years old.

Michael Jackson received 13 Grammy Awards during his life. He has been inducted into the Rock and Roll Hall of Fame once as a solo artist and once with the Jackson 5.

The 1980s

The 1980s was a decade of great accomplishment for African American entertainment. The new types of music called **hip-hop** and rap were gaining ground. The launch of MTV: Music Television in 1981 helped promote the careers of many performers, including African Americans. Lou Gossett Jr. won an Academy Award for best supporting actor in 1983. African American entertainers, especially in television, enjoyed widespread popularity.

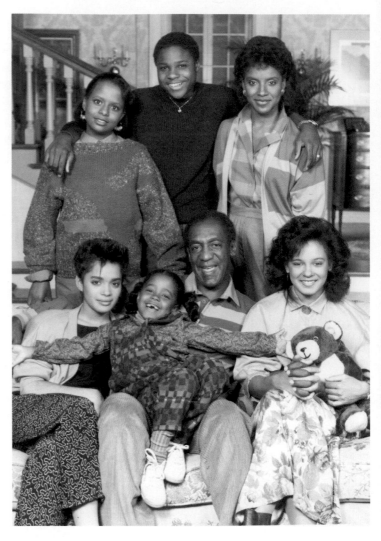

The Cosby Show, a sitcom about the Huxtable family, ran for eight seasons, from 1984 to 1992.

On Television

Different Strokes and *Webster* were popular television shows featuring African Americans in the 1980s. Television's biggest hit in the 1980s was the sitcom *The Cosby Show*. Comedian and activist Bill Cosby produced and starred in the weekly show. It won the highest ratings for a sitcom for five years in a row.

The show was a milestone in African American entertainment. Its universal appeal came from its endearing portrayal of an upper middle–class American family. Americans of all ethnic backgrounds could relate to the many issues and problems the family faced. It was the first of several commercially successful television shows with African American casts that appealed to large audiences in the 1990s.

Hip-hop and Rap

Hip-hop is a youth culture that grew out of the working class African American communities of the late 1970s and early 1980s. The term *hip-hop* referred to fashion, break dancing, and a type of music closely related to rap. Rap features rhyming chants over rhythmic music.

Different types of rap evolved during the 1980s. Rap pioneers such as Grandmaster Flash and the Furious Five, LL Cool J, and Run-DMC rapped about social problems facing African American youth in places such as the Bronx, a part of New York City. These artists helped pave the way for many of today's popular rap and hip-hop acts.

Quick Facts

With the rise of hip-hop, break dancing and urban dance also became popular. These art forms were developed on the streets. The 1984 movies *Breakin'* and *Beat Street* helped to bring hip-hop, rap, and break dancing into popular culture.

Trumpeter Wynton Marsalis is an accomplished musician who composes scores for films and music for the ballet. In 1984, he won Grammy Awards for both jazz and classical music recordings.

Dancer and choreographer Savion Glover took the lead role in *The Tap Dance Kid* on Broadway in 1984. He was 12 years old.

Run-DMC, formed in 1982, helped broaden the appeal of rap music.

Oprah Winfrey Builds an Empire

Oprah Winfrey is probably the most popular woman in the entertainment industry. After more than two decades, her influence on American television, film, and culture remains tremendous. During her historic career, Winfrey has worked as a talk show host, an actress, a magazine publisher, and a film and television producer.

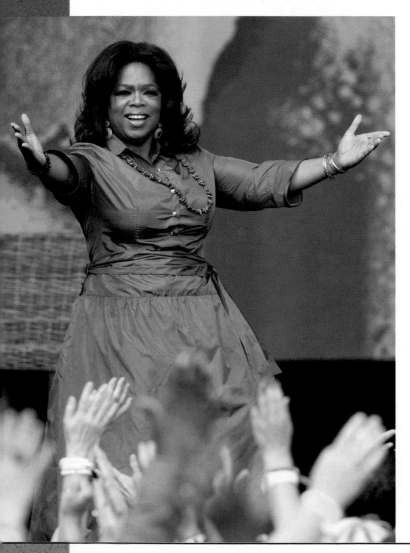

A Talk Show

Winfrey launched *The Oprah Winfrey Show* in 1986. She was the first African American woman to host a national talk show. Her show became the highest-rated talk show in the world, reaching more than 40 million viewers in 145 countries.

In 2009, Winfrey announced that she would end the show in its 25th season in 2011. Winfrey's goal was to encourage, entertain, and educate her mostly female audience. She encouraged self-improvement and often shared her own struggles.

A love of reading encouraged Winfrey to start a book club in 1996. Selections have included classic literature and contemporary novels. Oprah's Book Club turned books by unknown authors into bestsellers.

Other Achievements

In 1988, Oprah Winfrey became the first African American woman to run her own production company, Harpo Studios. The

In 2010, Oprah Winfrey took her show, and more than 300 of her fans, to Sydney, Australia. It was one of many special events that won high ratings for the show.

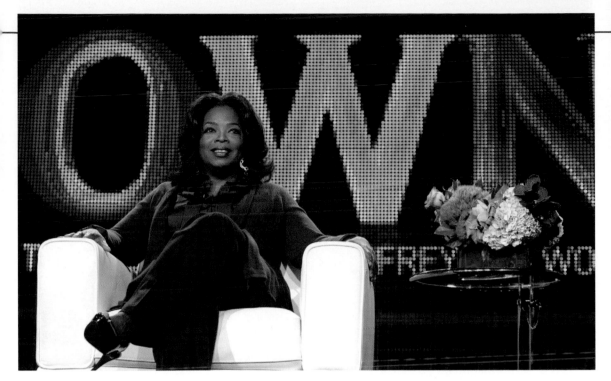

In 2011, Winfrey launched her own television channel, OWN: Oprah Winfrey Network.

name *Harpo* is *Oprah* spelled backward. In addition to running Winfrey's talk show, the company produced films such as *Beloved, Their Eyes Were Watching God*, and *Tuesdays with Morrie*. Winfrey also publishes a lifestyle magazine, *O: The Oprah Magazine*, and is the chair of her own television network.

Charities and Awards

A difficult childhood inspired in Winfrey a strong commitment to social justice issues. Her organizations, the Angel Network and the Oprah Winfrey Foundation, have raised millions of dollars. They support the education and empowerment of women and children around the world.

Winfrey has received many awards for her work, including a Lifetime Achievement Award from the National Academy of Television Arts and Sciences in 1998. She became the first female African American billionaire in 2003. Winfrey has been named several times to *Time* magazine's list of the 100 Most Influential People in the World.

Quick Facts

Oprah Winfrey was inducted into the NAACP Hall of Fame in 2005.

Oprah Winfrey campaigned for Barack Obama when he ran for president in 2007 and 2008. She drew huge crowds for the African American candidate.

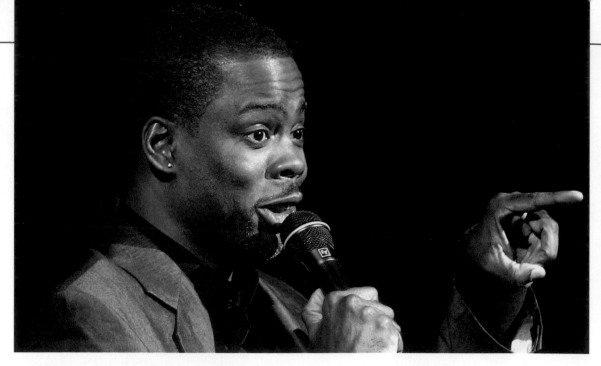

Actor and comedian Chris Rock addresses topical issues and race relations in his act.

The 1990s

African Americans continued to build a strong presence in the entertainment industry in the 1990s. Hip-hop music was gaining ground in the early 1990s. Radio stations began to play West Coast rappers, including Tupac Shakur.

R&B acts New Edition and Boyz II Men reintroduced the vocal style of earlier African American groups such as the Temptations. African American female groups enjoyed particular popularity. R&B group TLC had the highest-selling female group album ever in 1994. Destiny's Child, led by Beyoncé Knowles, was formed in 1995 and became one of the world's most popular R&B acts.

Comedy

A new generation of stand-up comics began to appear on the comedy scene. They toured to appreciative audiences around the country. African American entertainers Chris Rock, Sinbad, and Dave Chapelle starred in their own comedy specials on cable networks. Variety shows such as *In Living Color*, which brothers Keenen and Damon Wayans created and starred in, gave African Americans the opportunity to manage and develop their own ideas. Television sitcoms *The Fresh Prince of Bel-Air*, with Will Smith, and *Martin,* with Martin Lawrence,

were popular with audiences across the United States.

Awards in Film and Music

African Americans continued to enjoy success at the Academy Awards in the 1990s. In 1991, actress and comedian Whoopi Goldberg won for her supporting role in *Ghost*. In 1997, Cuba Gooding Jr. won for best supporting actor, in *Jerry Maguire*.

Recognition of African American achievement in the music industry also continued in the 1990s. In 1991, music producer and composer Quincy Jones received a Grammy Legend Award for his work in the recording field. A winner of 27 Grammy Awards, he has worked with Frank Sinatra, Michael Jackson, and Stevie Wonder. The legendary Wonder won a Grammy Award for lifetime achievement in 1996.

Spike Lee

One of the most influential African American filmmakers is writer, producer, director and actor Spike Lee. His first big hit was *She's Gotta Have It* in 1986. Lee's next film, *Do the Right Thing*, earned him an Academy Award nomination for original screenplay in 1990. Lee examined the life of the civil rights leader in *Malcolm X*, released in 1992.

Lee has inspired other African American directors, including John Singleton. Singleton was the first African American to be nominated for an Academy Award for best director, for his film *Boyz n the Hood*. At age 23, he was also the youngest director ever nominated for an Academy Award.

The 2000s and Beyond

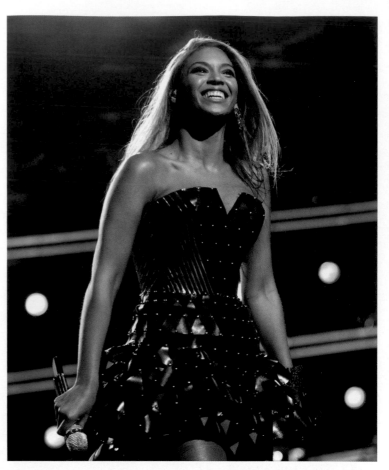

After singing as part of Destiny's Child, Beyoncé launched an extremely successful solo career.

By the 2000s, many African Americans were fully established as leaders in the entertainment industry. Rap and hip-hop dominated the music scene, becoming the most successful music style of its time. Music producers such as Timbaland and artists such as Missy Elliott and OutKast combined R&B, hip-hop, and pop to reach even wider audiences. African American artists such as Usher, Alicia Keys, Prince, and Beyoncé have fans around the world.

With actors producing their own movies, African Americans were increasingly gaining control of their film projects. A new generation of African American talent arrived on the scene with actors such as Jaden Smith, the son of actor and musician Will Smith. Jaden was the star of the 2010 remake of *The Karate Kid*.

At the Academy Awards

In the first decade of the 2000s, African Americans won 11 Academy Awards for achievement in film. In 2002, Halle Berry became the first African American to win an Academy Award for best actress, for her role in *Monster's Ball*. That same year, Denzel Washington won for best actor, for his role in *Training Day*. It was his second Academy Award. He won his first in 1990 for best supporting actor, in *Glory*. Also in 2002, Sidney Poitier was honored with an Academy Award for lifetime achievement.

In 2005, Jamie Foxx won an Academy Award for best actor, for his portrayal of Ray Charles in *Ray*. He also had a best supporting actor nomination for his role in *Collateral*. Foxx lost, however, to another African American actor, Morgan Freeman, for his role as a boxing trainer in *Million Dollar Baby*.

Double success came again in 2006. Forest Whitaker, the star of *The Last King of Scotland*, took home an Academy Award for best actor. Jennifer Hudson, who debuted on the big screen in *Dreamgirls*, won for best supporting actress.

The 2009 film *Precious* won a best supporting actress Academy Award for Mo'Nique and best adapted screenplay award for writer Geoffrey Fletcher. Other talented African Americans actors nominated for Academy Awards include James Earl Jones, Samuel L. Jackson, Diana Ross, and Eddie Murphy. Each success encourages greater achievements ahead for African American entertainers.

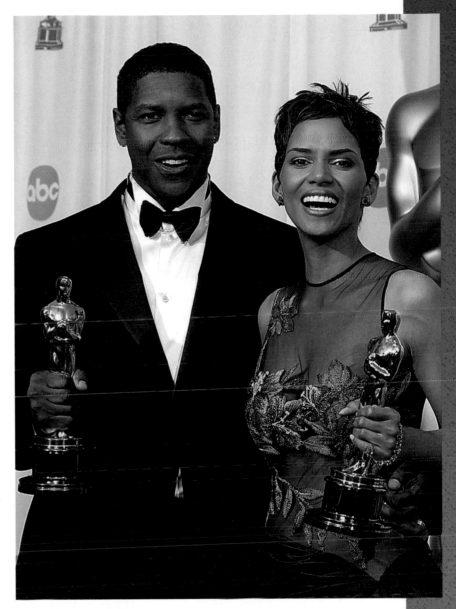

With wins in both best actor and best actress categories, 2002 was an historic year for African American entertainment.

Timeline

1619: Africans are captured and brought to Jamestown, Virginia, to work as slaves.

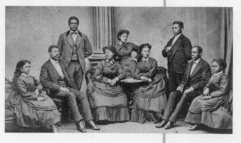

1865: The 13th Amendment to the U.S. Constitution officially abolishes slavery.

1871: The Fisk Jubilee Singers, a group of men and women performers, organize at Fisk University in Nashville, Tennessee, to tour the United States and Europe.

1899

1899: Scott Joplin publishes "Maple Leaf Rag," which eventually sells more than one million copies of sheet music.

1901: Entertainers Bert Williams and George Walker record "Good Afternoon Mr. Jenkins," one of the first recordings by African American artists.

1922: A young jazz musician named Louis Armstrong plays trumpet in Chicago, Illinois.

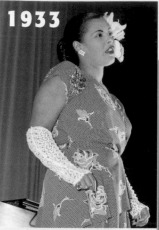

1933

1933: Singer Billie Holiday is discovered while performing in a club in New York's Harlem.

1939: After being denied the use of a "whites only" hall in Washington, D.C., Marian Anderson performs at the Lincoln Memorial.

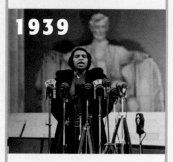

1939

1940: Hattie McDaniel becomes the first African American to win an Oscar, for her role as Mammy in the 1939 film *Gone with the Wind.*

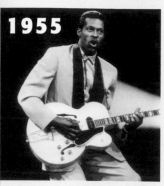

1955

1955: Chuck Berry records his hit song "Maybellene." Opera singer Marian Anderson becomes the first African American woman to perform with the Metropolitan Opera Company in New York City.

1956: Arthur Mitchell becomes the first African American dancer in the New York City Ballet.

1959: Berry Gordy Jr. founds Motown Records. Lorraine Hansberry's *A Raisin in the Sun* becomes the first drama written by an African American woman to open on Broadway.

1600 **1800** **1930** **1950**

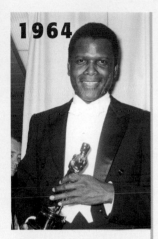

1964

1964: Sidney Poitier wins an Academy Award for best actor in the film *Lilies of the Field*.

1964: The U.S. Congress passes the Civil Rights Act of 1964 outlawing discrimination in most public facilities.

1965: Bill Cosby wins a leading role in the dramatic television series *I Spy*.

1965

1971: Musician and music historian Joshua Rifkin records *Scott Joplin: Piano Rags*, which sells more than one million copies.

1972: *Fat Albert and the Cosby Kids*, the first entirely African American television cartoon, created and hosted by Bill Cosby, airs on a national network.

1973: Stevie Wonder wins a Grammy Award for best album.

1977: About 130 million viewers watch Alex Haley's *Roots: The Saga of an American Family* on national television.

1981: MTV: Music Television is launched.

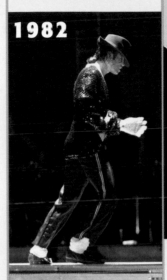

1982

1982: Michael Jackson releases the album *Thriller*.

1984: *The Cosby Show* debuts on network television.

1991: John Singleton becomes the first African American and the youngest person to be nominated for an Academy Award for best director, for his film *Boyz n the Hood*.

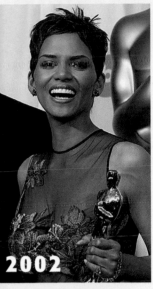

2002

2002: Halle Berry becomes the first African American to win an Academy Award for best actress, for her role in *Monster's Ball*.

2006: Jennifer Hudson wins an Academy Award for best supporting actress, for her role in *Dreamgirls*. Forest Whitaker wins for best actor, for his role in *The Last King of Scotland*.

2009: Michael Jackson dies at age 50.

2011: After 25 seasons, *The Oprah Winfrey Show* airs its final program.

1960 **1970** **1980** **2010**

Activity

What Is an Entertainer?

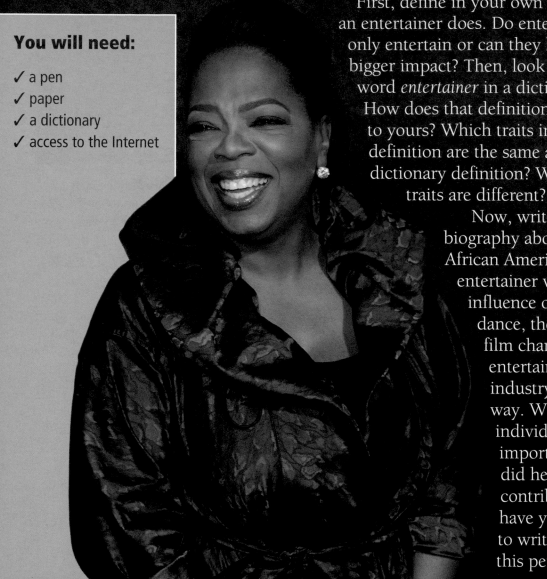

An entertainer is someone who engages others through performance. Entertainers can amuse, challenge, and inspire us. In this activity, you will examine what makes a great entertainer. First, define in your own words what an entertainer does. Do entertainers only entertain or can they have a bigger impact? Then, look up the word *entertainer* in a dictionary. How does that definition compare to yours? Which traits in your definition are the same as the dictionary definition? Which traits are different?

Now, write a short biography about an African American entertainer whose influence on music, dance, theater, or film changed the entertainment industry in some way. Why is this individual so important? What did he or she contribute? Why have you chosen to write about this person?

You will need:

✓ a pen
✓ paper
✓ a dictionary
✓ access to the Internet

Test Your Knowledge

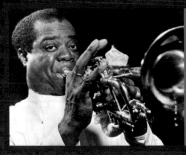

Q Louis Armstrong was the inventor of what type of singing?

A Scat singing

Q What was the title of the Chuck Berry song that many people say started rock and roll?

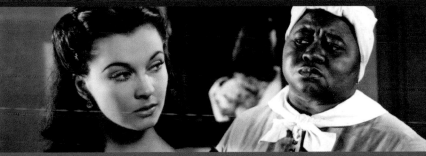

Q Who was the first African American to win an Oscar for acting?

A Hattie McDaniel

A "Maybellene"

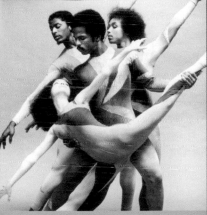

Q Who founded Motown Records?

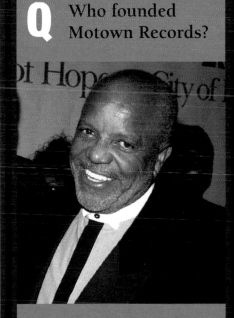

Q When did Michael Jackson release his *Thriller* album?

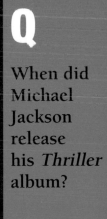

Q Who started an African American modern dance ensemble in 1958?

A Alvin Ailey

A Berry Gordy

A 1982

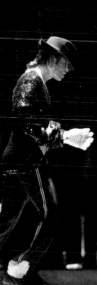

Glossary

blaxploitation films: films made by and for African Americans that some people believed exploited African Americans

blues: a style of music that developed from African American spirituals, work songs, and field hollers of the nineteenth century

civil rights: the basic rights guaranteed to citizens

Civil Rights Act of 1964: an act passed in 1964 by the U.S. Congress that outlawed discrimination in most public facilities

civil rights movement: the movement for gaining equal rights for African Americans

discrimination: unfair treatment due to prejudice

ensemble: a group of dancers, players, or singers

field hollers: traditional call-and-answer songs sung by slaves working in plantation fields

gospel music: a type of religious music that combines jazz, spirituals, and folk music

Great Migration: the movement in the 1910s and 1920s of millions of African Americans to northern states

hip-hop: a culture and a type of music closely related to rap and African American inner-city life

improvisation: inventing, composing, or performing without preparation

inducted: admitted as a member

jazz: a style of American music developed from ragtime and blues

Jim Crow laws: laws that supported segregation in the southern states

lyrics: the words of a song

minstrel shows: racist performances, popular through the early 1900s, featuring actors wearing black makeup with exaggerated features

race films: movies written, produced, and directed by African Americans for African American audiences; these films, popular in the 1940s, featured African American casts

racist: someone who discriminates based on a person's race

ragtime: a style of jazz with a steady rhythm and an accented accompaniment

rapper: a performer of rhyming chants over rhythmic music

rhythm and blues: a style of music developed by African Americans that combines blues and jazz

scat singing: a type of vocalizing that uses syllables, nonsense words, and sounds made in a rhythmic way

segregation: a forced separation of races

sitcom: short for *situation comedy*, a television comedy series with continuing characters

soloing: performing by oneself

soul: music developed by African Americans that combines gospel music and R&B

spirituals: religious songs developed especially among African Americans in the South

stereotypes: oversimplified images or opinions of a group

tempos: the rates of speed that a performer plays a piece of music

variety shows: theatrical entertainment of separate performances

vaudeville: performances featuring song and dance, juggling, magic, and comedy acts

work songs: music sung in rhythm with work

Index

Log on to www.av2books.com

AV² by Weigl brings you media enhanced books that support active learning. Go to www.av2books.com, and enter the special code found on page 2 of this book. You will gain access to enriched and enhanced content that supplements and complements this book. Content includes video, audio, web links, quizzes, a slide show, and activities.

Audio
Listen to sections of the book read aloud.

Video
Watch informative video clips.

Embedded Weblinks
Gain additional information for research.

Try This!
Complete activities and hands-on experiments.

WHAT'S ONLINE?

Try This!	Embedded Weblinks	Video	EXTRA FEATURES
Test your knowledge of important events in African American entertainment history.	Find out more about the history of African Americans in entertainment.	Watch a video about African Americans entertainers.	**Audio** Listen to sections of the book read aloud.
Write a biography about a notable African American entertainer.	Learn more about notable people from *Great African Americans–Entertainment*.	Watch a video about a notable moment of African Americans in entertainment.	**Key Words** Study vocabulary, and complete a matching word activity.
Create a timeline of important events in an African American entertainer's life.	Link to more notable achievements of African American entertainers.		**Slide Show** View images and captions, and prepare a presentation.
Complete a writing activity about an important topic in the book.			**Quizzes** Test your knowledge.
Design your own magazine.			

AV² was built to bridge the gap between print and digital. We encourage you to tell us what you like and what you want to see in the future.

Sign up to be an AV² Ambassador at www.av2books.com/ambassador.